THE RAVEN

Illustrations by
Gustave Doré

Poem by
Edgar Allan Poe

DOVER PUBLICATIONS, INC.
NEW YORK

Bibliographical Note

This Dover edition, first published in 1996, reproduces the text of "The Raven" from a standard edition, along with the illustrations by Gustave Doré as published by Harper & Brothers, New York, in 1884. A new Publisher's Note has been written specially for the present edition.

Library of Congress Cataloging-in-Publication Data

Poe, Edgar Allan, 1809–1849.
 The raven / illustrations by Gustave Doré ; poem by Edgar Allan Poe.
 p. cm.
 "This Dover edition, first published in 1996, reproduces the text of 'the Raven' from a standard edition, along with the illustrations by Gustave Doré as published by Harper & Brothers, New York, in 1884" — T.p. verso.
 ISBN 0-486-29072-7 (pbk.)
 1. Fantastic poetry, American — Illustrations. I. Doré, Gustave, 1832–1883. II. Title.
PS2609.A1 1996
811'.3 — dc20 95-45989
 CIP

Manufactured in the United States of America
Dover Publications, Inc., 31 East 2nd Street, Mineola, N.Y. 11501

Publisher's Note

Perhaps the most famous American poem, Edgar Allan Poe's "The Raven" was published in 1845 (first in the *New York Mirror;* later that year in *The Raven and Other Poems*). Poe had earlier gained recognition for his talents for works such as the story "The Gold Bug" (for which he had won a $100 prize from a Philadelphia periodical in 1843), but it was "The Raven" that secured him a wide reputation and increased his presence in New York's literary circles.

Poe's reputation continued to grow after his death in 1849, and his work soon gained a foreign readership. In 1852 Charles Baudelaire wrote a series of critical assessments in the *Revue de Paris,* and went on to translate many Poe stories, but only one of his poems — "The Raven." It was this translation that Edouard Manet used as the basis for the lithographs he executed in 1875, and which Gustave Doré, the most popular and prolific illustrator of the nineteenth century, also used as the text for his illustrations — his last published work, appearing a year after his death in 1883.

The illustrations bear all the hallmarks that had distinguished Doré's work throughout his career: extremely theatrical compositions incorporating violent bodily contortions, vivid contrasts of light and dark and grotesqueries of all sorts. The plates contain reminiscences of earlier Doré works — the Dante illustrations (p. 5), the figure of Death from *The Rime of the Ancient Mariner* (p. 21), the French Renaissance châteaux that figure in Perrault's tales and Tennyson's *Idylls of the King* (p. 23) and the very figure of the raven itself. (Doré had early discovered that one way of emphasizing a bleak, mysterious or malignant landscape was to pepper it liberally with ravens and bats.)

Doré is able to create a feeling of claustrophobia in the setting he devises for "The Raven." Although he takes the reader beyond the room in several illustrations, it is that confined space, dimly lighted and on many occasions filled with the obsessions that litter the neurotic subject's soul, that remains in the memory, a sense of suffocation being established in the first plate, in which a figure is smothered in drapery. (The image is prefigured in the headpiece to Book III, Chapter 19, of Doré's 1873 edition of Rabelais' *Gargantua and Pantagruel.* In that illustration, however, the figure is pressing to the left, rather than to the right, as it does in "The Raven.")

If the illustrations lack the full polish that Doré's finishing hand would have provided, they nevertheless afford ample proof that the master had retained his imagination and craft to the end.

The Raven

Once upon a midnight dreary, while I pondered, weak and weary,
Over many a quaint and curious volume of forgotten lore —
While I nodded, nearly napping, suddenly there came a tapping,
As of some one gently rapping, rapping at my chamber door.
" 'T is some visitor," I muttered, "tapping at my chamber door —
 Only this and nothing more."

Ah, distinctly I remember it was in the bleak December;
And each separate dying ember wrought its ghost upon the floor.
Eagerly I wished the morrow; — vainly I had sought to borrow
From my books surcease of sorrow — sorrow for the lost Lenore —
For the rare and radiant maiden whom the angels name Lenore —
 Nameless *here* for evermore.

And the silken, sad, uncertain rustling of each purple curtain
Thrilled me — filled me with fantastic terrors never felt before;
So that now, to still the beating of my heart, I stood repeating
" 'T is some visitor entreating entrance at my chamber door —
Some late visitor entreating entrance at my chamber door; —
 This it is and nothing more."

Presently my soul grew stronger; hesitating then no longer,
"Sir," said I, "or Madam, truly your forgiveness I implore;
But the fact is I was napping, and so gently you came rapping,
And so faintly you came tapping, tapping at my chamber door,
That I scarce was sure I heard you" — here I opened wide the door; —
 Darkness there and nothing more.

Deep into that darkness peering, long I stood there wondering, fearing,
Doubting, dreaming dreams no mortal ever dared to dream before;
But the silence was unbroken, and the stillness gave no token,
And the only word there spoken was the whispered word, "Lenore!"
This I whispered, and an echo murmured back the word "Lenore!"
 Merely this and nothing more.

Back into the chamber turning, all my soul within me burning,
Soon again I heard a tapping somewhat louder than before.
"Surely," said I, "surely that is something at my window lattice;
Let me see, then, what thereat is, and this mystery explore —
Let my heart be still a moment and this mystery explore; —
 'T is the wind and nothing more!"

Open here I flung the shutter, when, with many a flirt and flutter,
In there stepped a stately Raven of the saintly days of yore.
Not the least obeisance made he; not a minute stopped or stayed he;
But, with mien of lord or lady, perched above my chamber door —
Perched upon a bust of Pallas just above my chamber door —
 Perched, and sat, and nothing more.

Then this ebony bird beguiling my sad fancy into smiling,
By the grave and stern decorum of the countenance it wore,
"Though thy crest be shorn and shaven, thou," I said, "art sure no
 craven,
Ghastly grim and ancient Raven wandering from the Nightly shore —
Tell me what thy lordly name is on the Night's Plutonian shore!"
 Quoth the Raven, "Nevermore."

Much I marvelled this ungainly fowl to hear discourse so plainly,
Though its answer little meaning — little relevancy bore;
For we cannot help agreeing that no living human being
Ever yet was blessed with seeing bird above his chamber door —
Bird or beast upon the sculptured bust above his chamber door,
 With such name as "Nevermore."

But the Raven, sitting lonely on the placid bust, spoke only
That one word, as if his soul in that one word he did outpour.
Nothing farther then he uttered — not a feather then he fluttered —
Till I scarcely more than muttered "Other friends have flown before —
On the morrow *he* will leave me, as my hopes have flown before."
 Then the bird said "Nevermore."

Startled at the stillness broken by reply so aptly spoken,
"Doubtless," said I, "what it utters is its only stock and store
Caught from some unhappy master whom unmerciful Disaster
Followed fast and followed faster till his songs one burden bore —
Till the dirges of his Hope that melancholy burden bore
 Of 'Never — nevermore.'"

But the Raven still beguiling all my fancy into smiling,
Straight I wheeled a cushioned seat in front of bird, and bust and door;
Then, upon the velvet sinking, I betook myself to linking
Fancy unto fancy, thinking what this ominous bird of yore —
What this grim, ungainly, ghastly, gaunt, and ominous bird of yore
 Meant in croaking "Nevermore."

This I sat engaged in guessing, but no syllable expressing
To the fowl whose fiery eyes now burned into my bosom's core;
This and more I sat divining, with my head at ease reclining
On the cushion's velvet lining that the lamp-light gloated o'er,
But whose velvet violet lining with the lamp-light gloating o'er,
 She shall press, ah, nevermore!

Then, methought, the air grew denser, perfumed from an unseen censer
Swung by Seraphim whose foot-falls tinkled on the tufted floor.
"Wretch," I cried, "thy God hath lent thee—by these angels he hath
 sent thee
Respite—respite and nepenthe from thy memories of Lenore;
Quaff, oh quaff this kind nepenthe and forget this lost Lenore!"
 Quoth the Raven "Nevermore."

"Prophet!" said I, "thing of evil!—prophet still, if bird or devil!—
Whether Tempter sent, or whether tempest tossed thee here ashore,
Desolate yet all undaunted, on this desert land enchanted—
On this home by Horror haunted—tell me truly, I implore—
Is there—*is* there balm in Gilead?—tell me—tell me, I implore!"
 Quoth the Raven "Nevermore."

"Prophet!" said I, "thing of evil!—prophet still, if bird or devil!
By that Heaven that bends above us—by that God we both adore—
Tell this soul with sorrow laden if, within the distant Aidenn,
It shall clasp a sainted maiden whom the angels name Lenore—
Clasp a rare and radiant maiden whom the angels name Lenore."
 Quoth the Raven "Nevermore."

"Be that word our sign of parting, bird or fiend!" I shrieked,
 upstarting—
"Get thee back into the tempest and the Night's Plutonian shore!
Leave no black plume as a token of that lie thy soul hath spoken!
Leave my loneliness unbroken!—quit the bust above my door!
Take thy beak from out my heart, and take thy form from off my door!"
 Quoth the Raven "Nevermore."

And the Raven, never flitting, still is sitting, *still* is sitting
On the pallid bust of Pallas just above my chamber door;
And his eyes have all the seeming of a demon's that is dreaming,
And the lamp-light o'er him streaming throws his shadow on the floor;
And my soul from out that shadow that lies floating on the floor
 Shall be lifted—nevermore!

THE RAVEN

["Nevermore"]

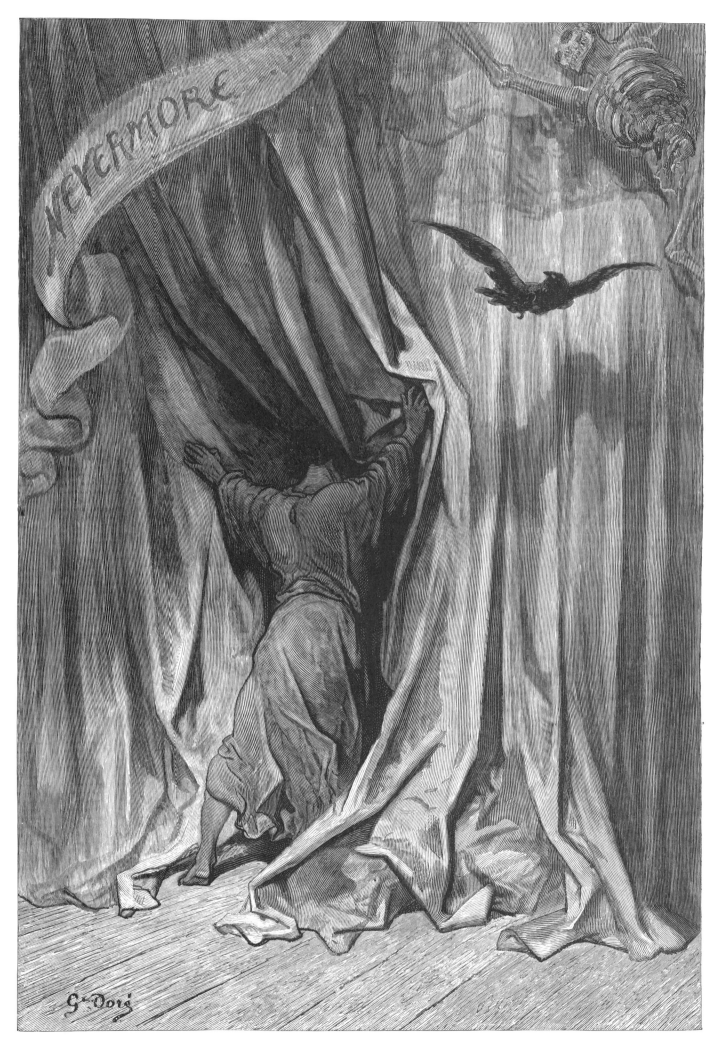

[ΑΝΑΓΚΗ (Inevitability)]

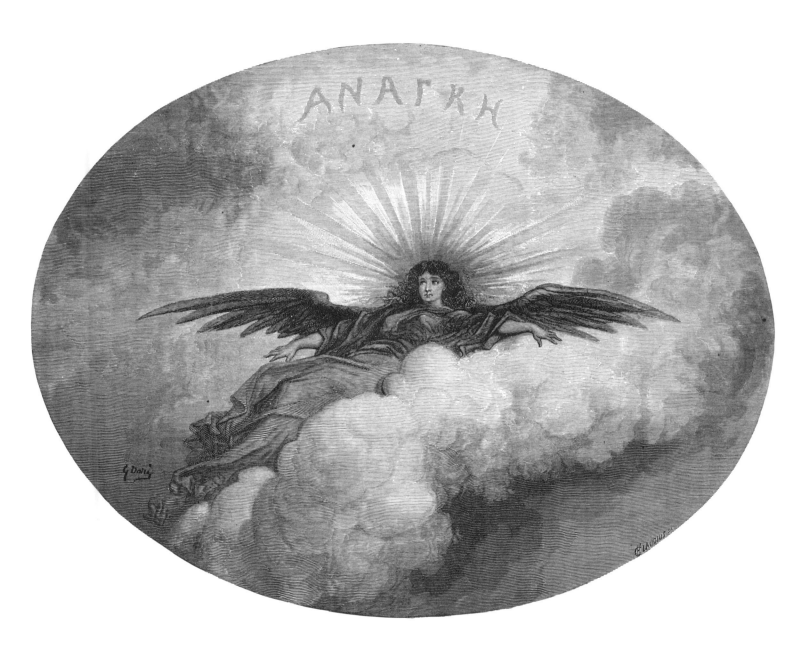

Once upon a midnight dreary, while I pondered, weak and weary,
Over many a quaint and curious volume of forgotten lore—

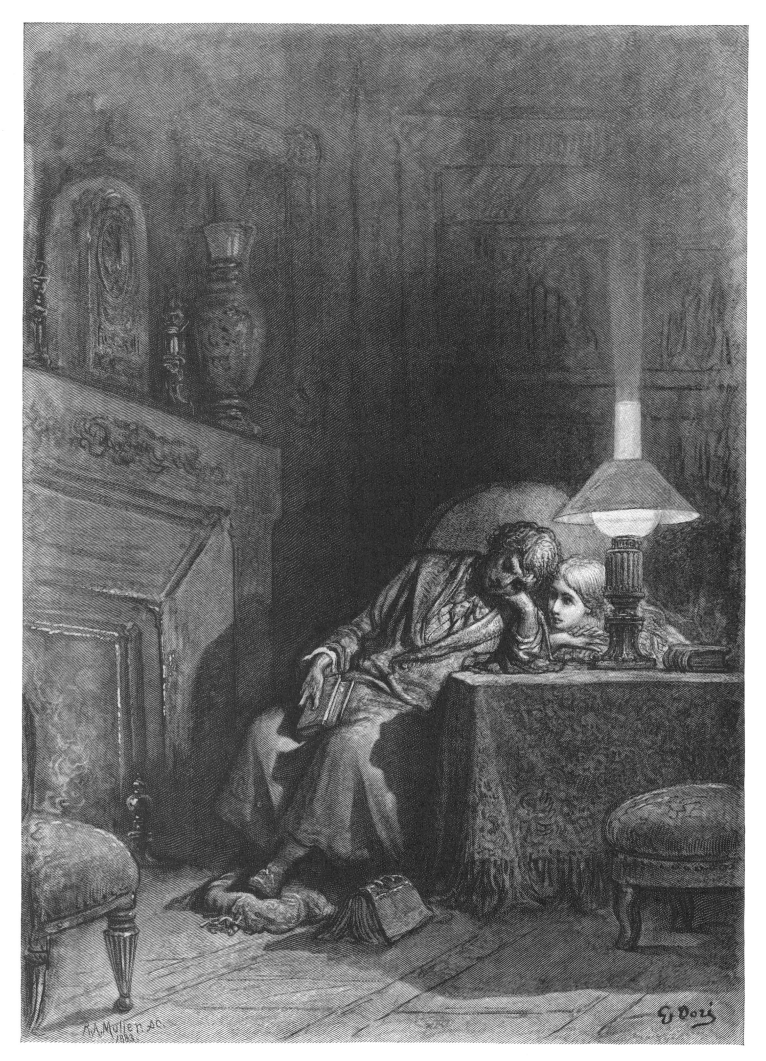

Ah, distinctly I remember it was in the bleak December;
And each separate dying ember wrought its ghost upon the floor.

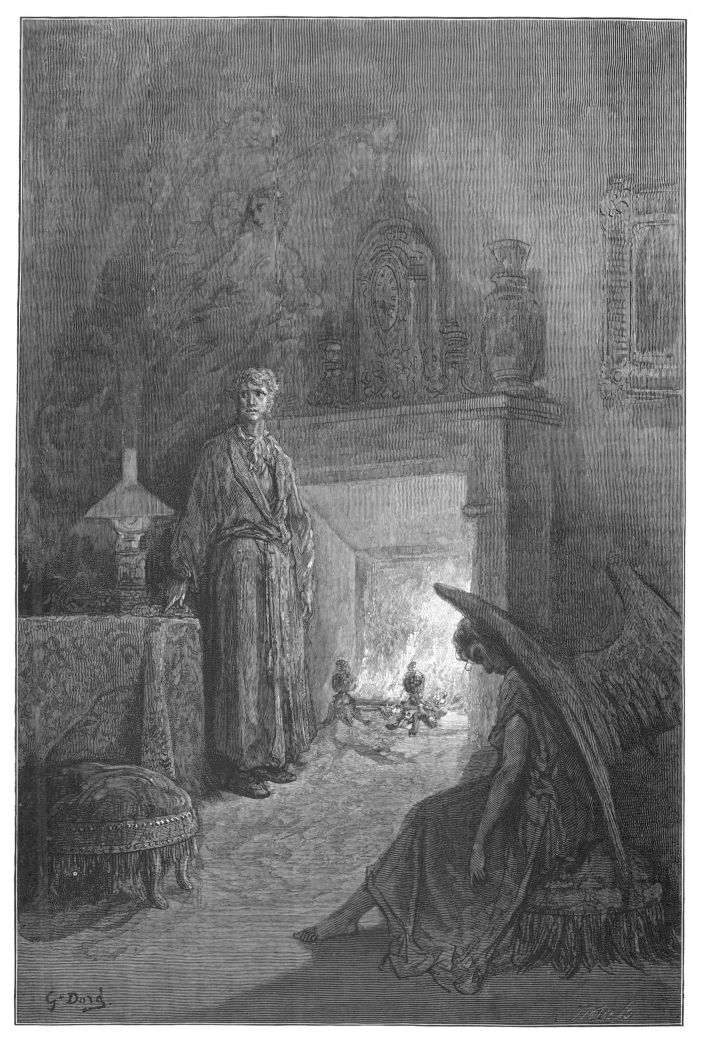

Eagerly I wished the morrow; — vainly I had sought to borrow
From my books surcease of sorrow — sorrow for the lost Lenore —

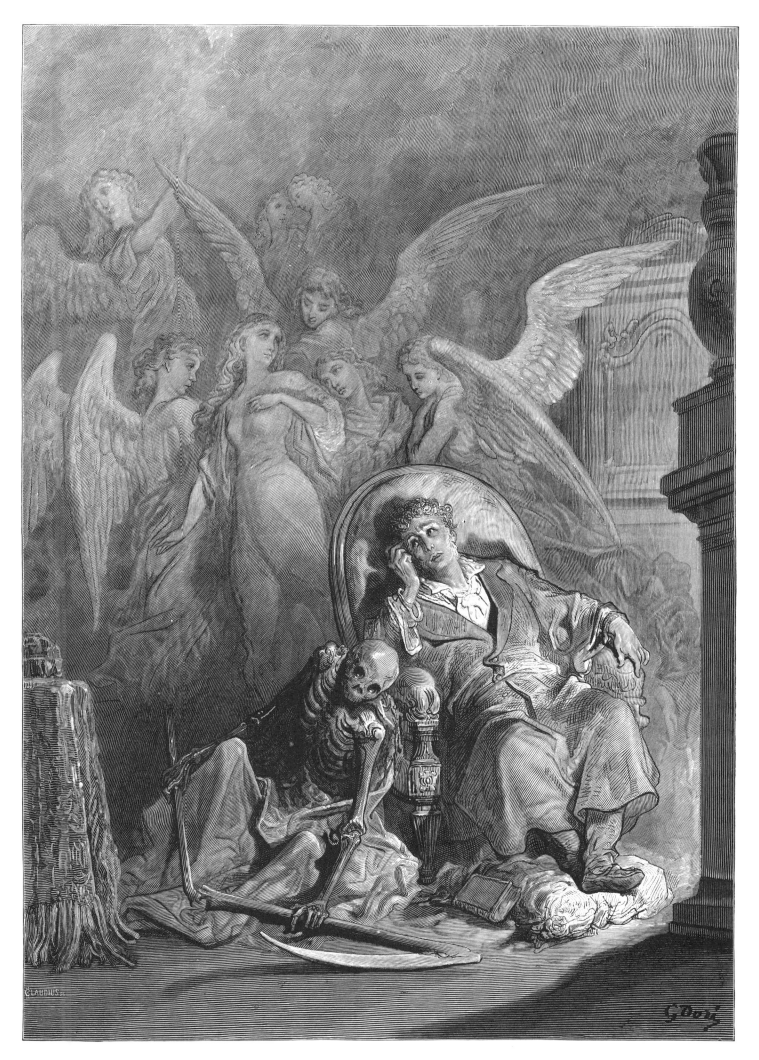

Sorrow for the lost Lenore.

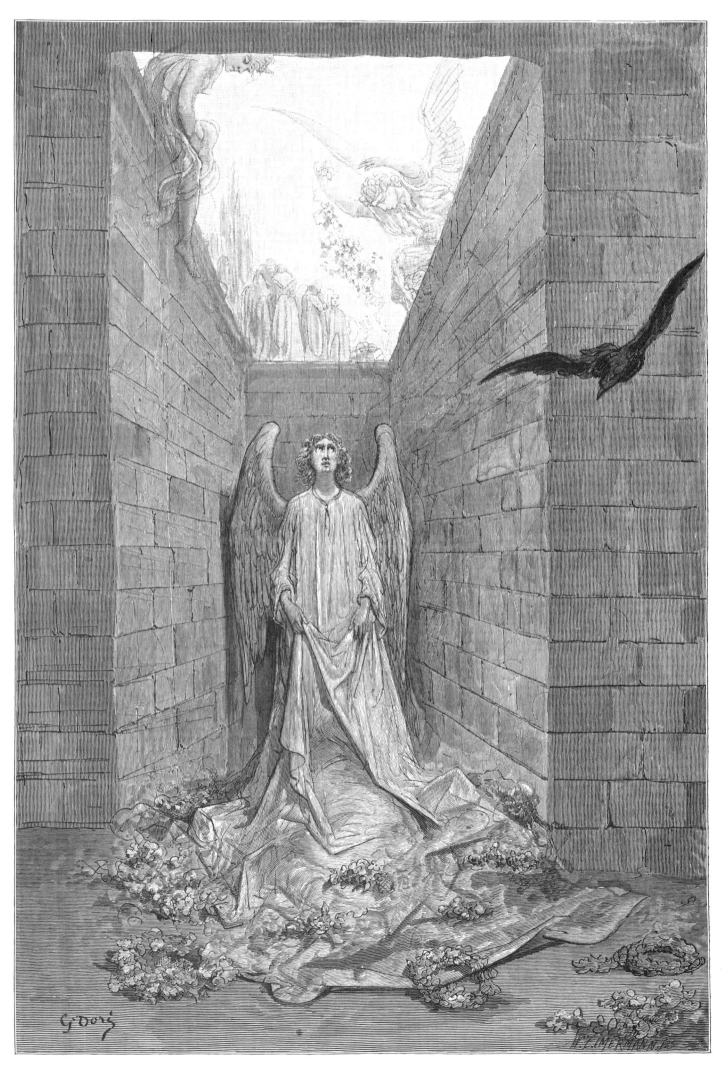

For the rare and radiant maiden whom the angels name Lenore—
Nameless *here* for evermore.

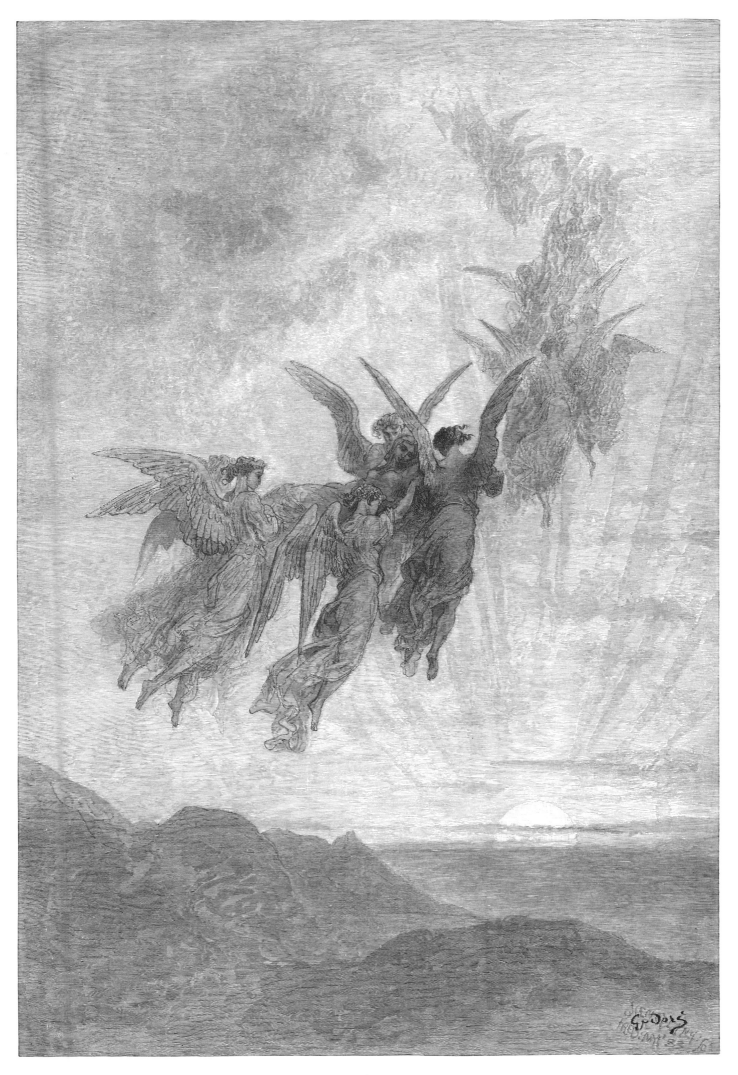

" 'T is some visitor entreating entrance at my chamber door —
Some late visitor entreating entrance at my chamber door; — . . ."

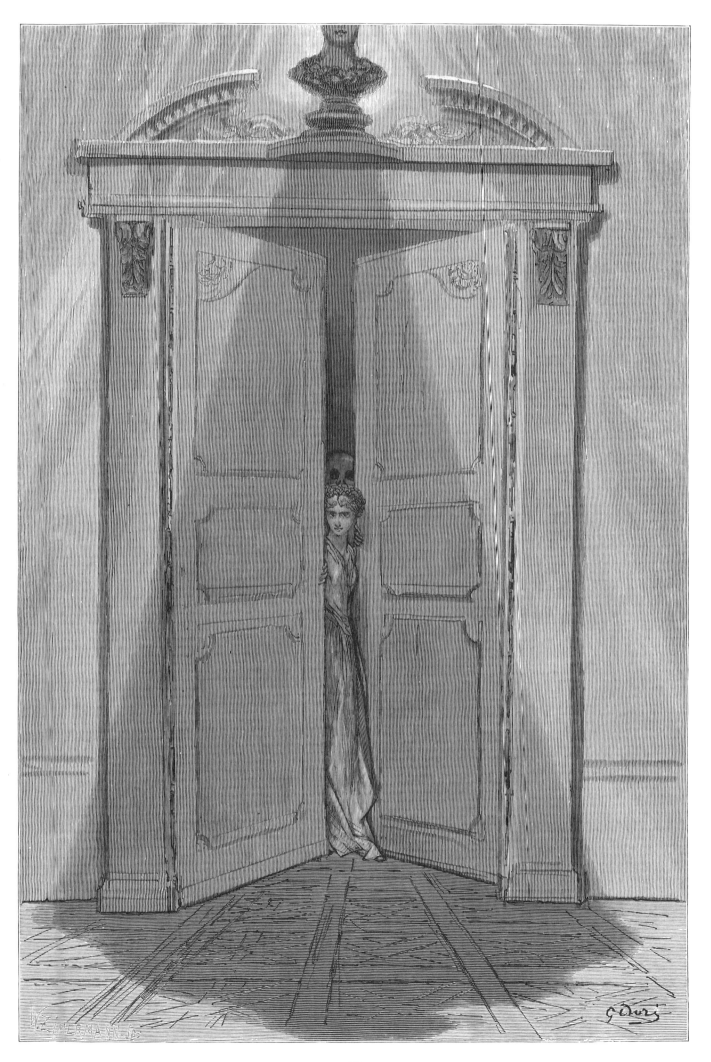

. . . here I opened wide the door; —
 Darkness there and nothing more.

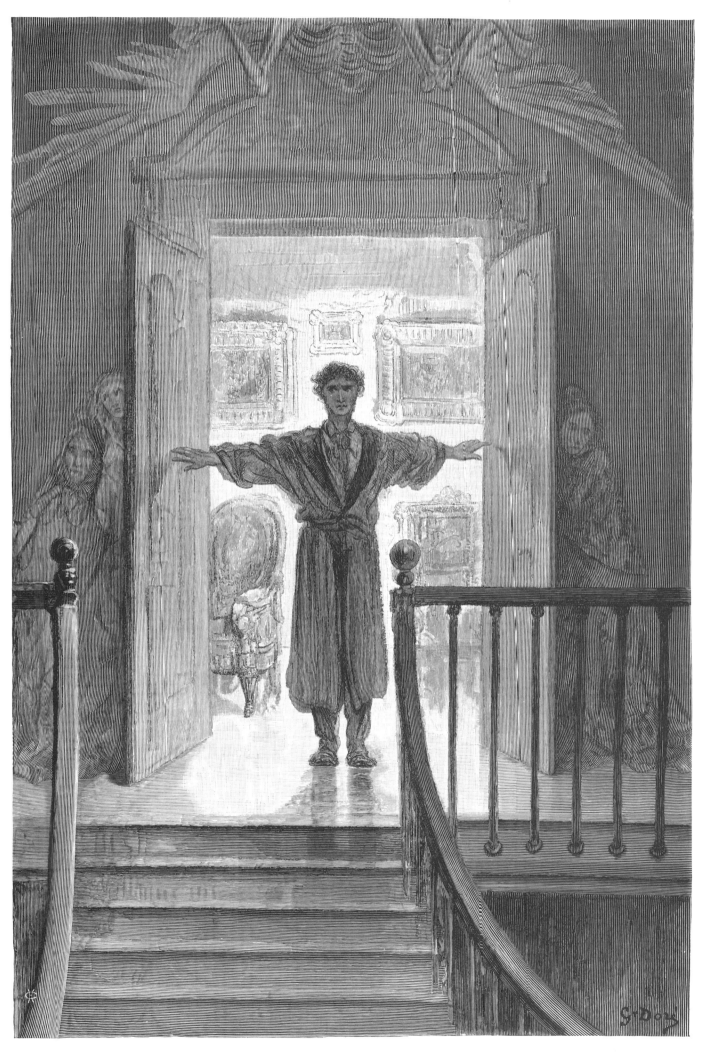

Doubting, dreaming dreams no mortal ever dared to dream before; . . .

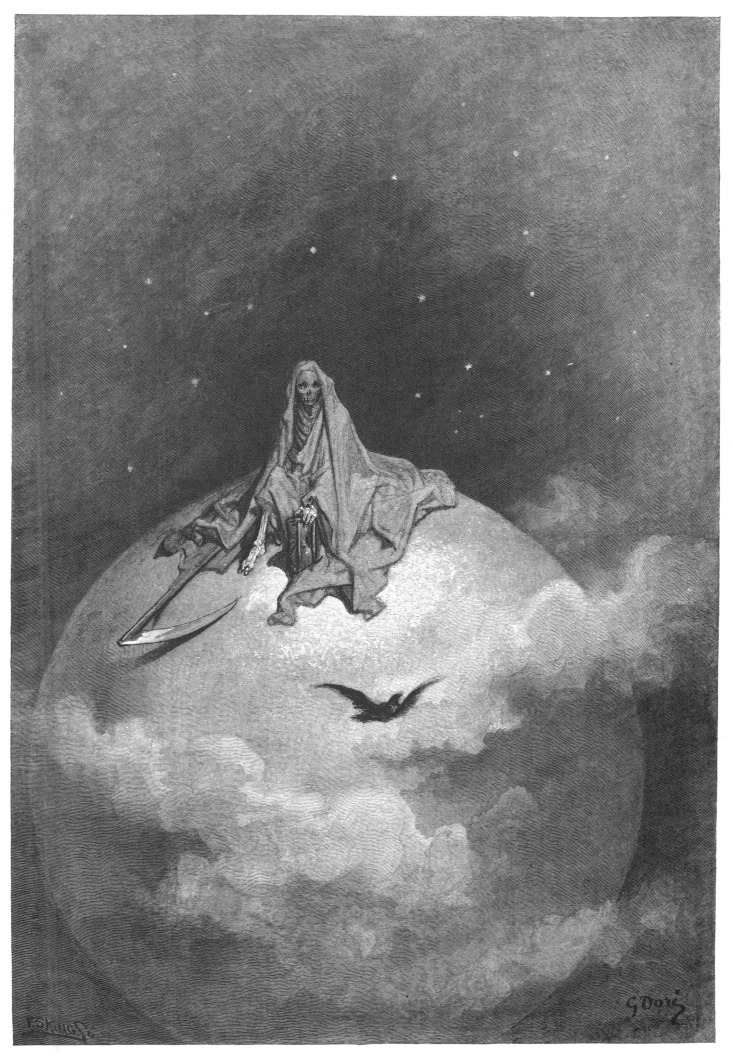

"Surely," said I, "surely that is something at my window lattice;
Let me see, then, what thereat is, and this mystery explore — . . ."

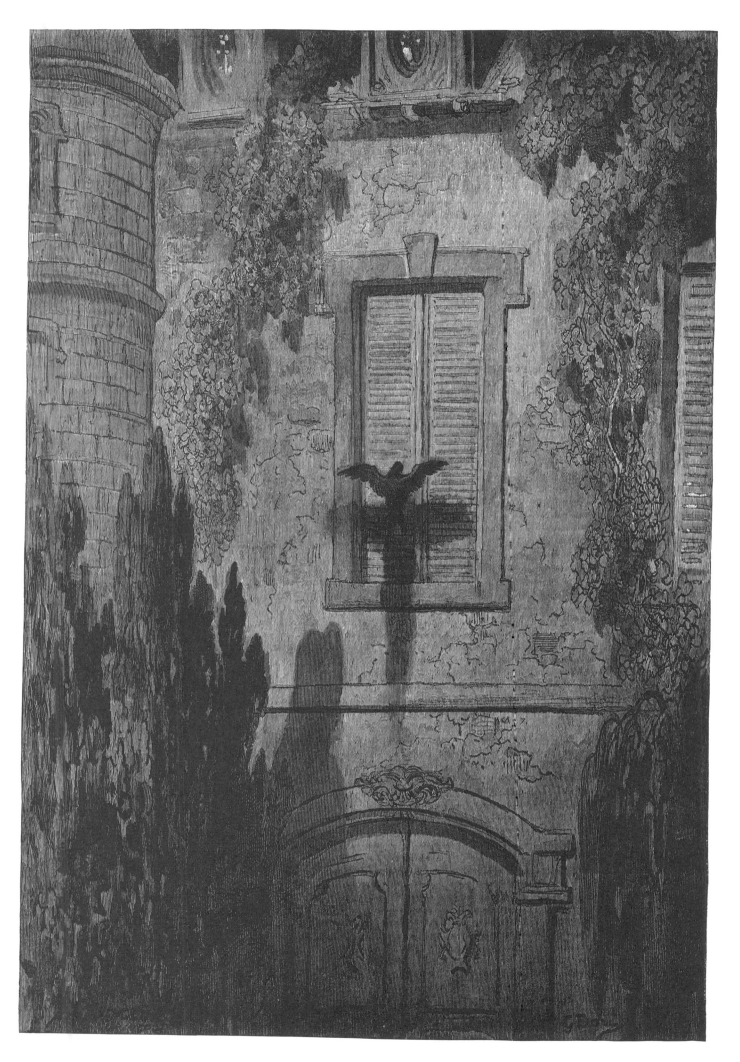

Open here I flung the shutter, . . .

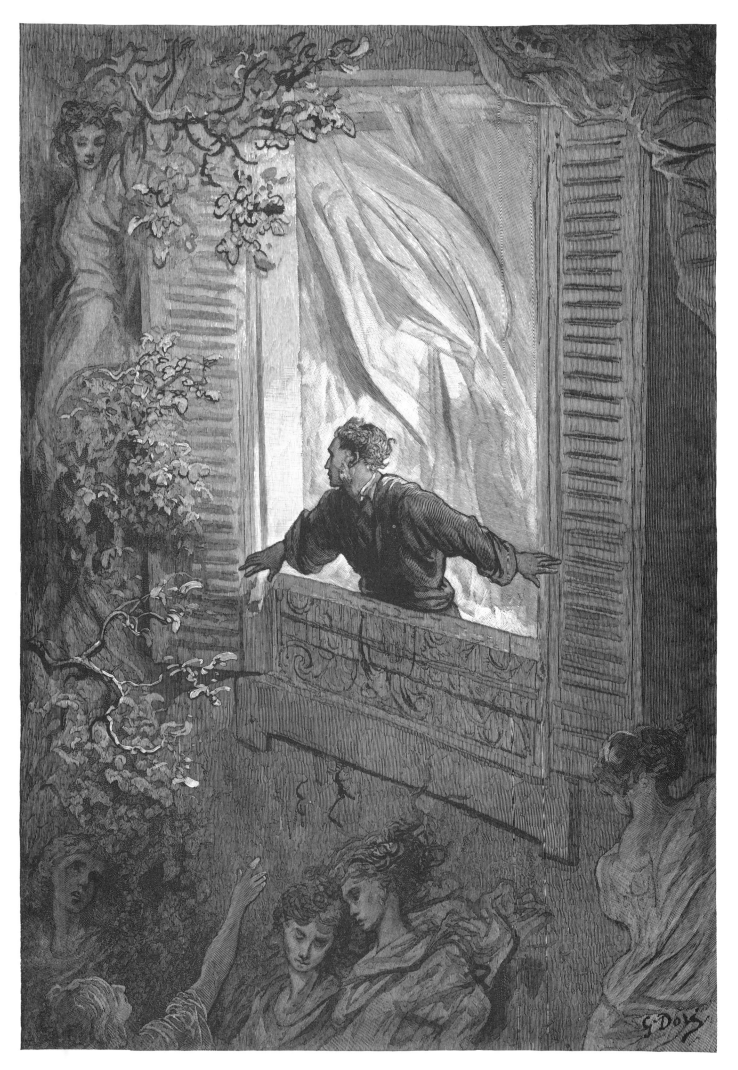

. . . a stately Raven of the saintly days of yore.

Not the least obeisance made he; not a minute stopped or stayed he; . . .

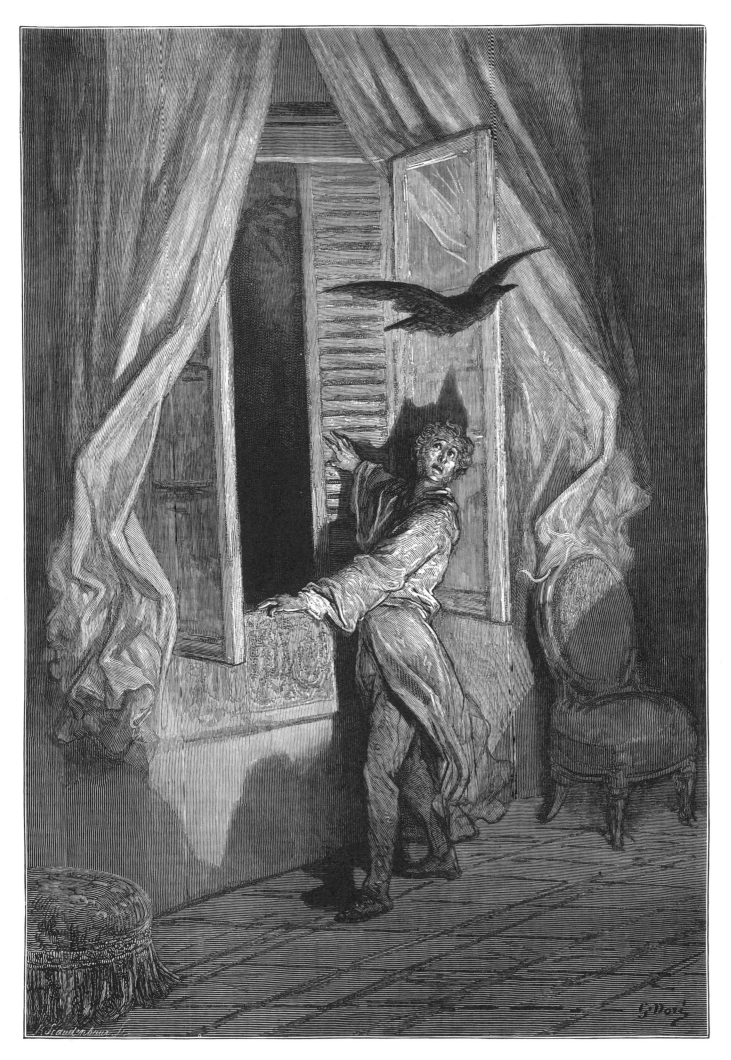

Perched upon a bust of Pallas just above my chamber door —
Perched, and sat, and nothing more.

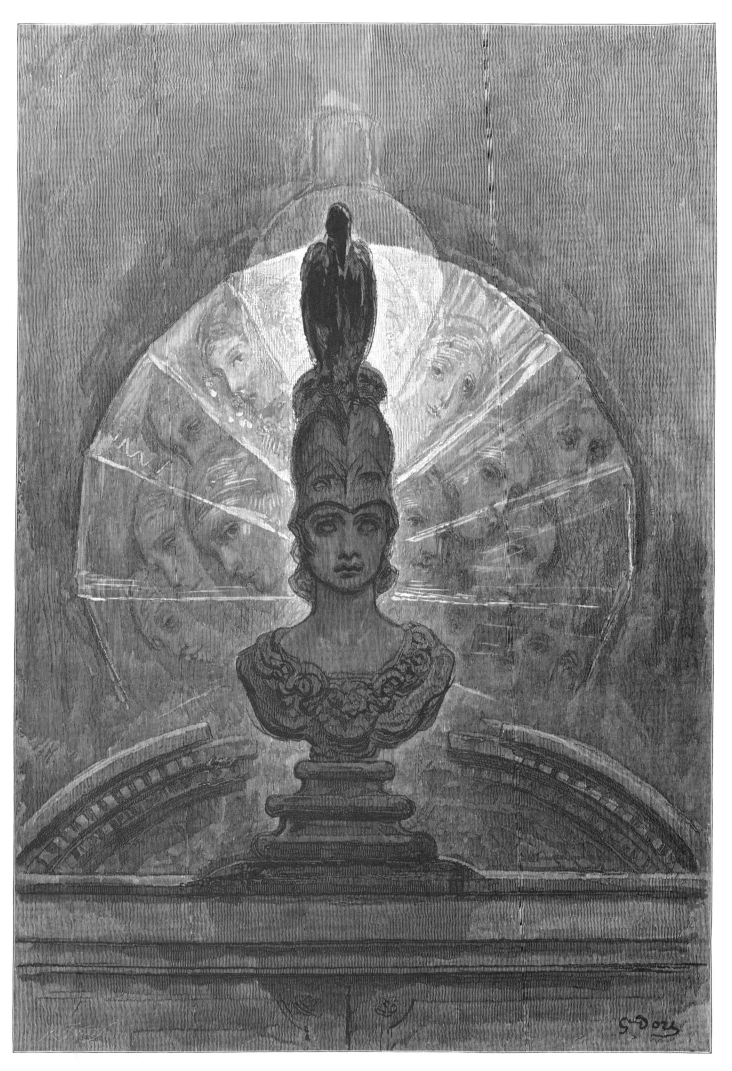

" . . . wandering from the Nightly shore — . . ."

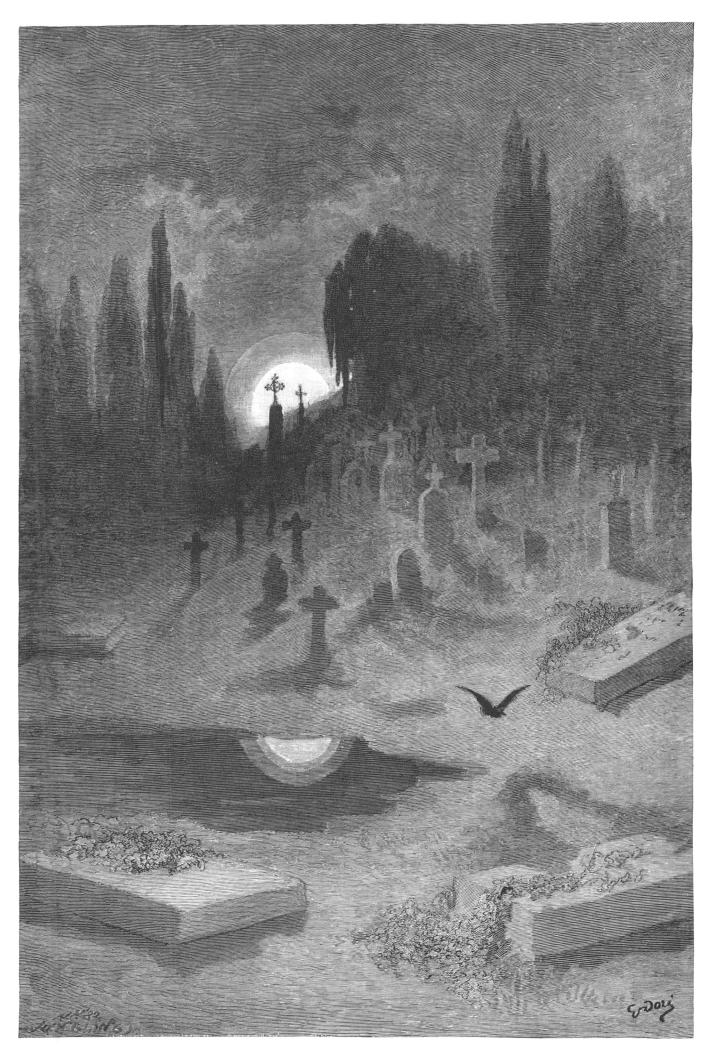

Till I scarcely more than muttered "Other friends have flown before —
On the morrow *he* will leave me, as my hopes have flown before."

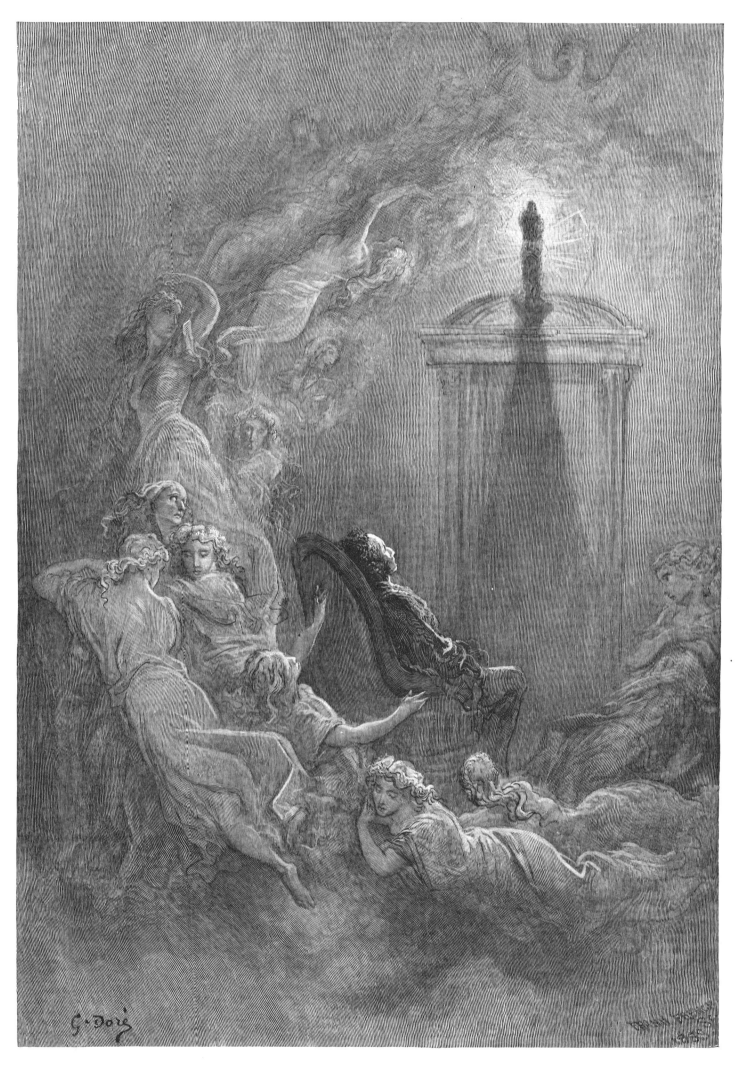

Then, upon the velvet sinking, I betook myself to linking
Fancy unto fancy, . . .

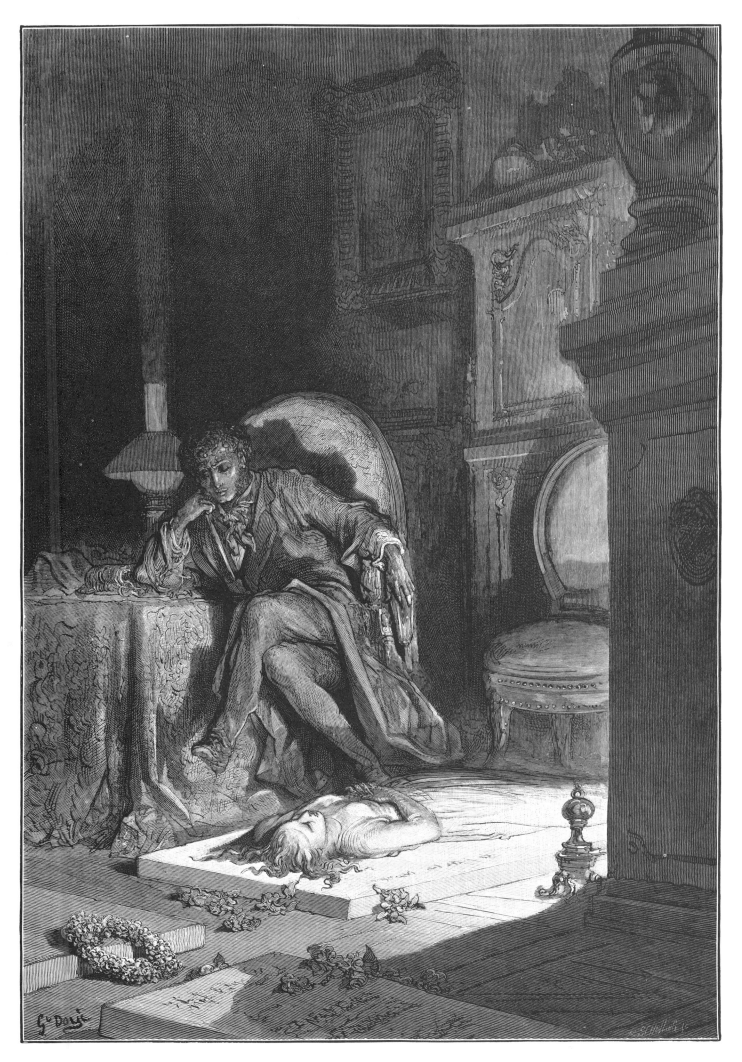

But whose velvet violet lining with the lamp-light gloating o'er,
She shall press, ah, nevermore!

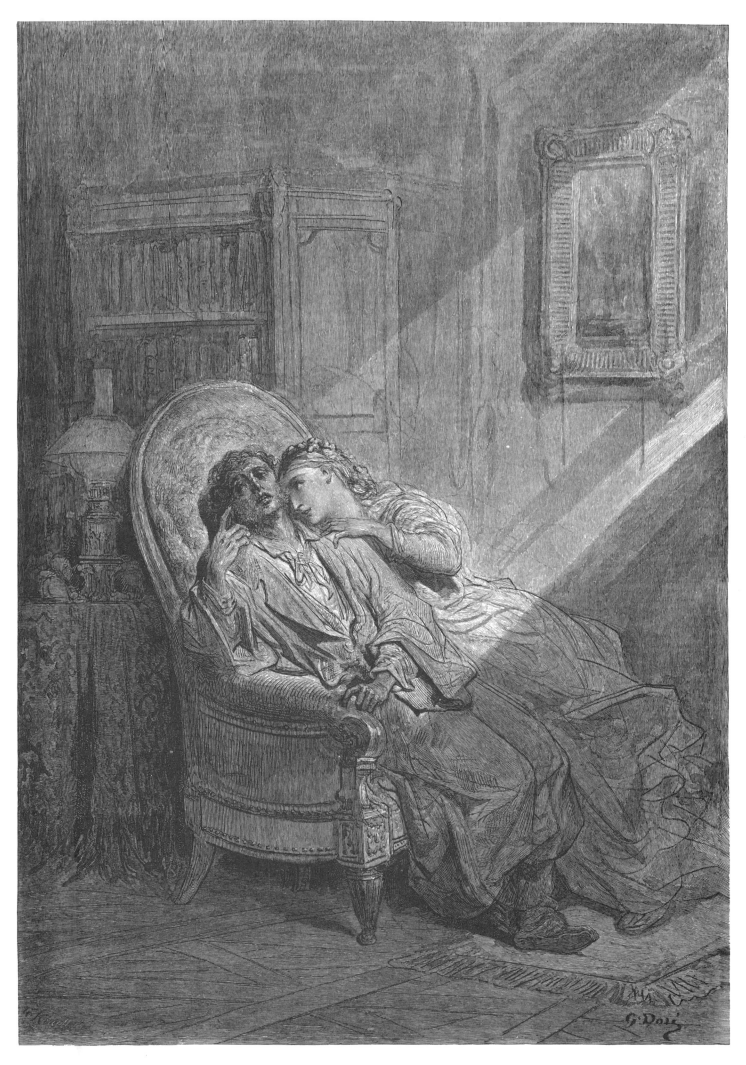

"Wretch," I cried, "thy God hath lent thee — by these angels he hath sent thee
Respite — respite and nepenthe from thy memories of Lenore; . . ."

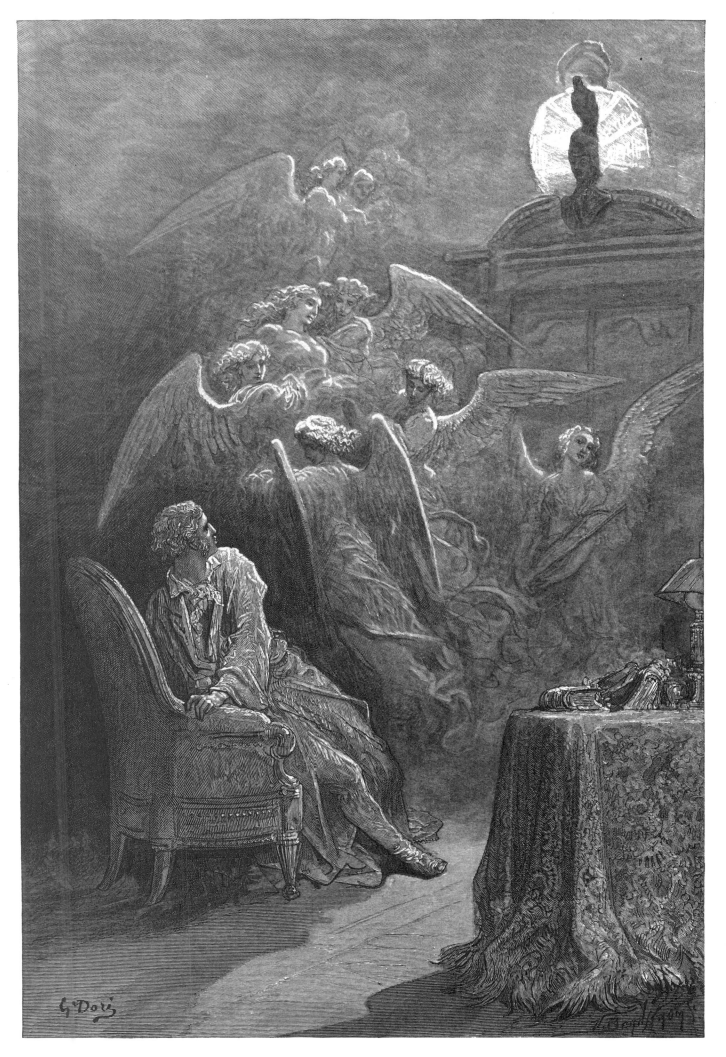

"On this home by Horror haunted — . . ."

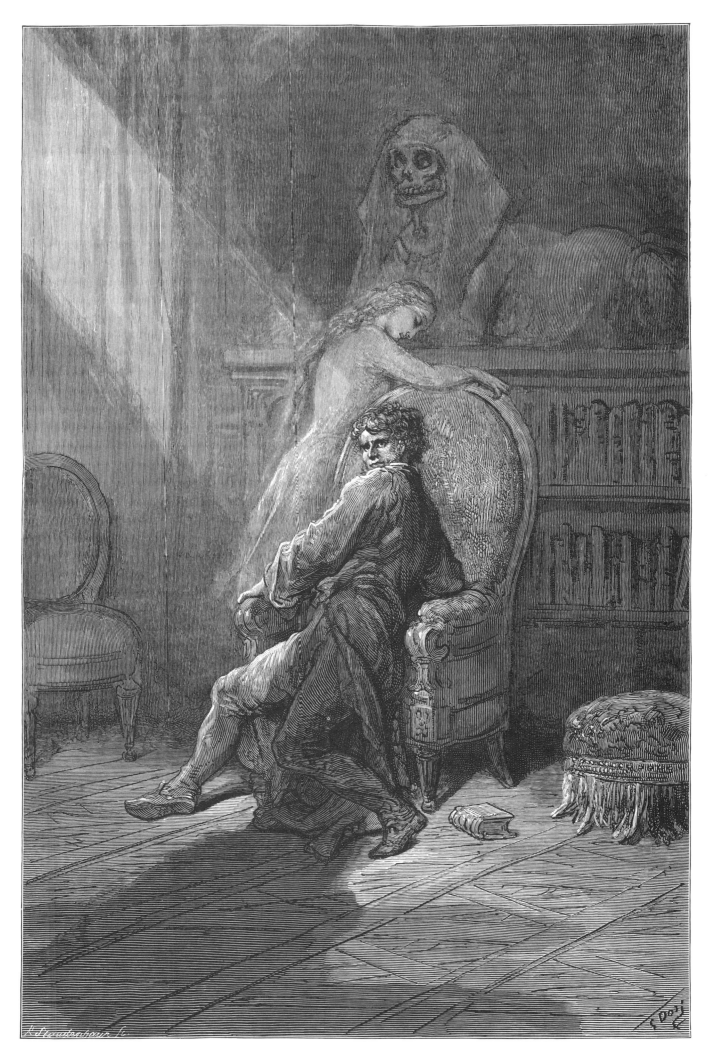

" . . . tell me truly, I implore —
Is there — *is* there balm in Gilead? — tell me — tell me, I implore!"

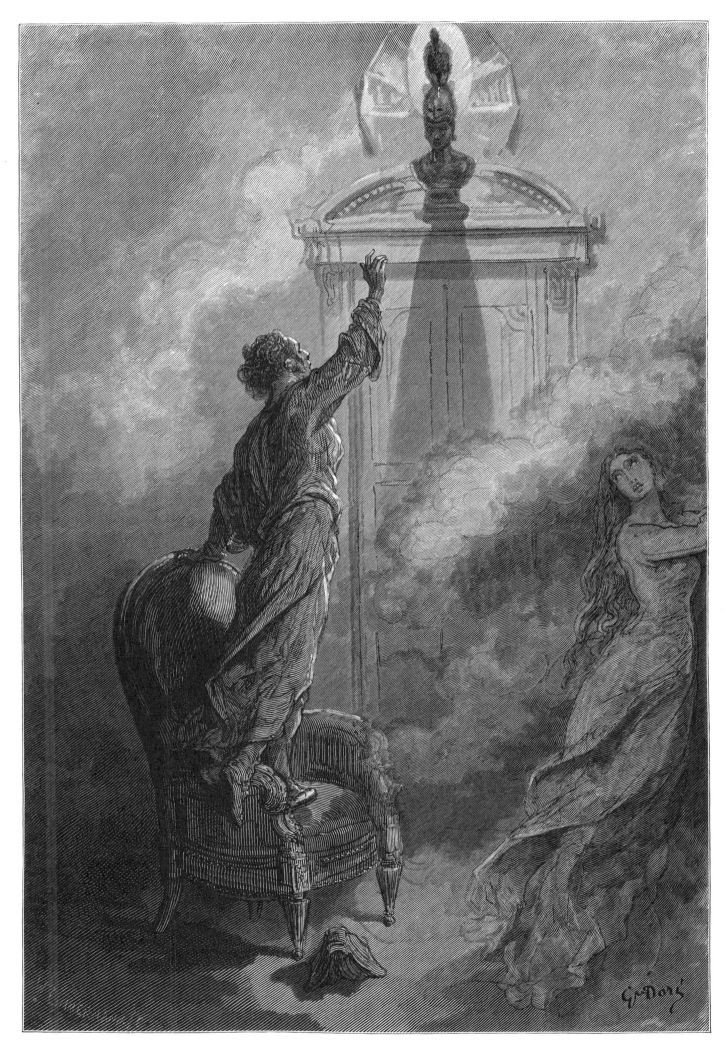

"Tell this soul with sorrow laden if, within the distant Aidenn,
It shall clasp a sainted maiden whom the angels name Lenore—"

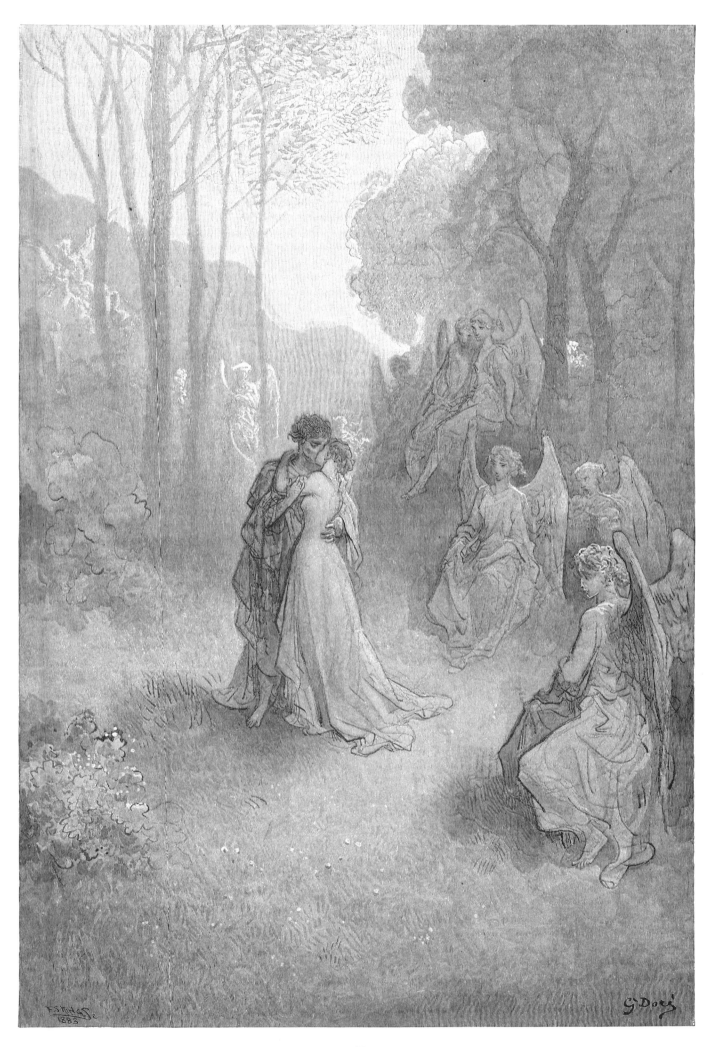

"Be that word our sign of parting, bird or fiend!" I shrieked, upstarting—

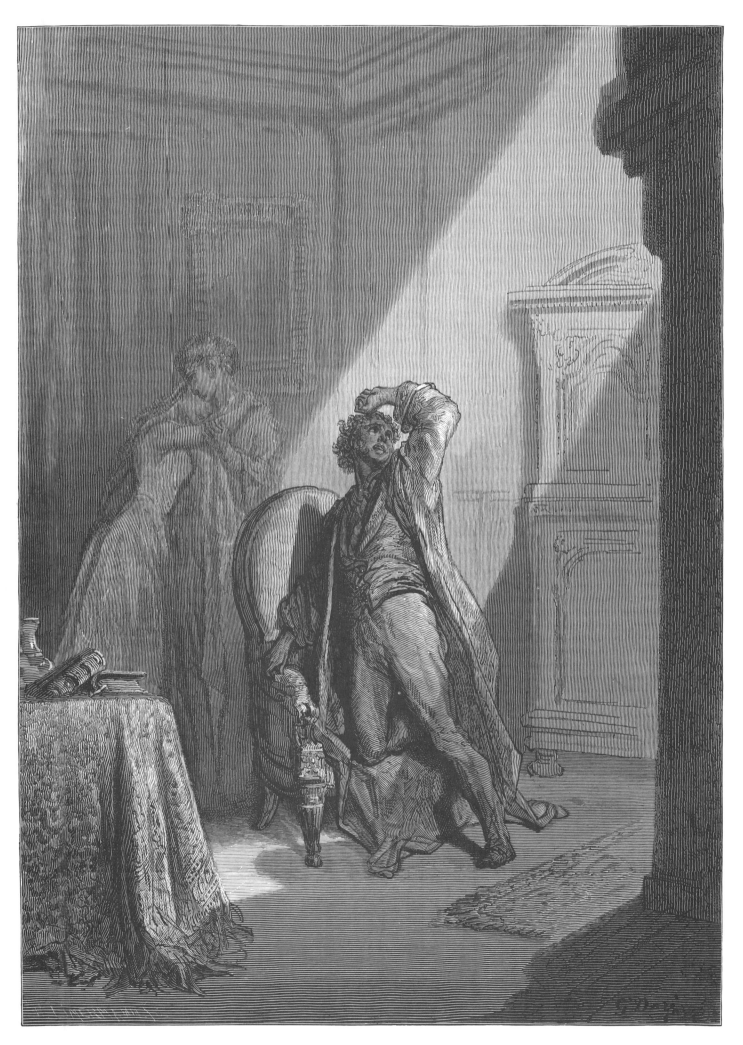

"Get thee back into the tempest and the Night's Plutonian shore!"

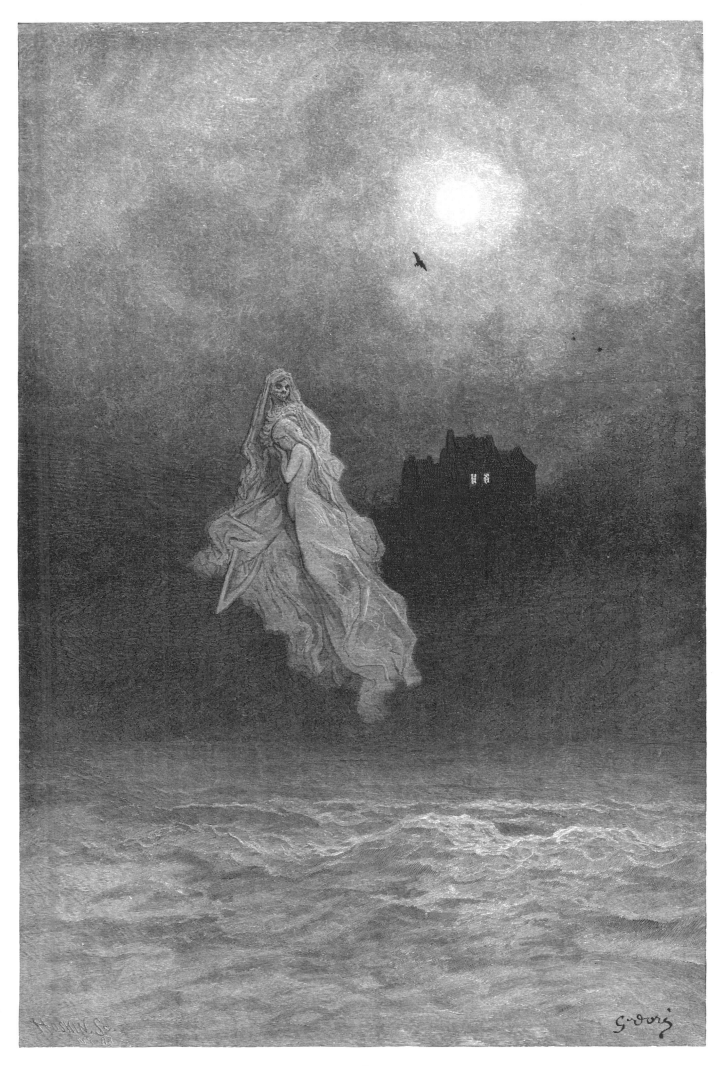

And my soul from out that shadow that lies floating on the floor
Shall be lifted — nevermore!

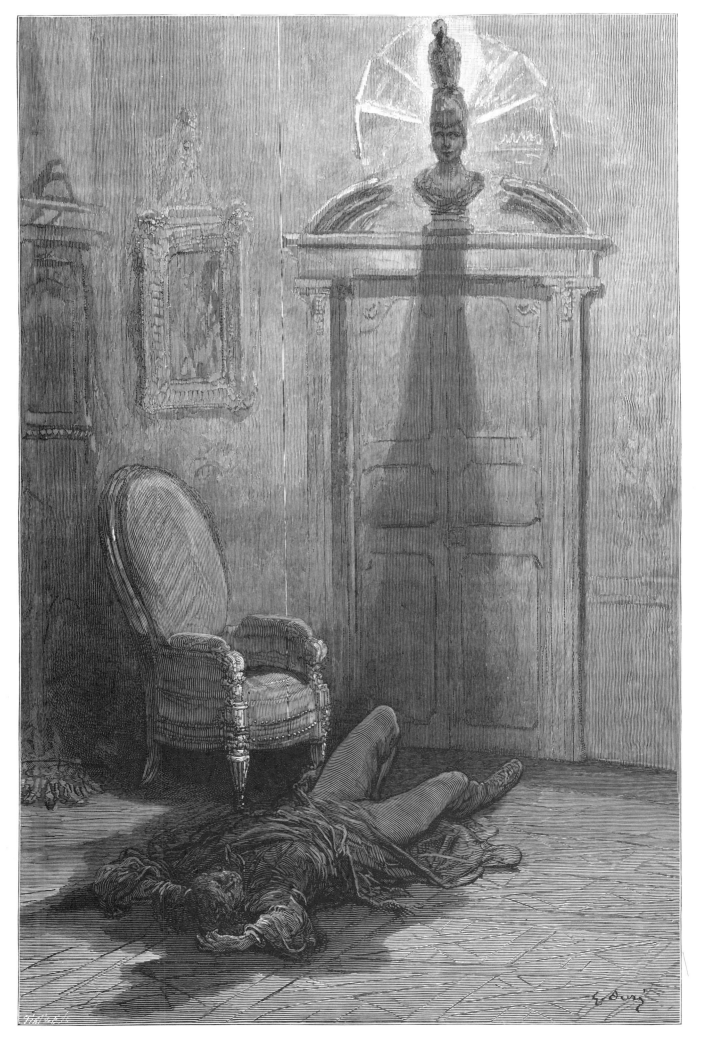

[The secret of the Sphinx]

Mai. 2001